CW00920089

Dedicated to
my Mother and my Father

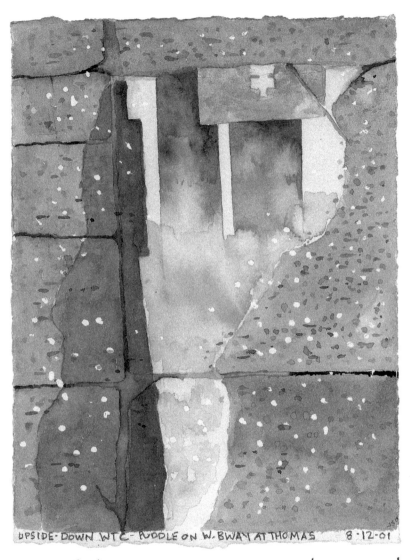

UPSIDE-DOWN WTC - PUDDLE ON W. BWAY AT THOMAS 8·12·01

Out of the Ruins – A New York Record
Lower Manhattan, Autumn 2001
Jean Holabird

GINGKO PRESS

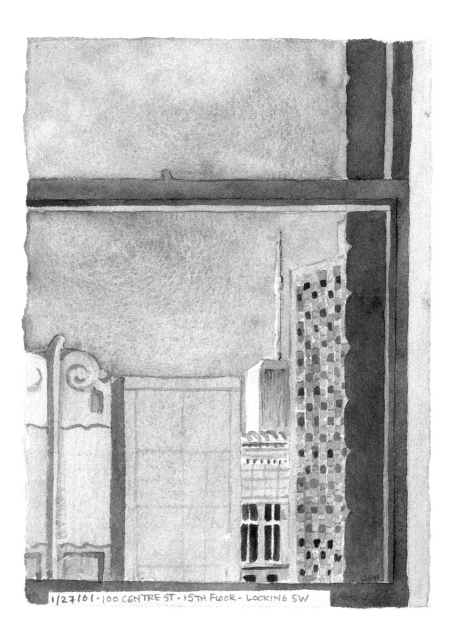

1/27/01 · 100 CENTRE ST · 15TH FLOOR · LOOKING SW

E.B. White

HERE IS NEW YORK

All dwellers in cities must live with the stubborn fact of
annihilation; in New York the fact is somewhat more
concentrated because of the concentration of the city
itself, and because, of all targets, New York has a
certain clear priority. In the mind of whatever perverted
dreamer might loose the lightning, New York must hold
a steady, irresistible charm.

Summer 1948

excerpt

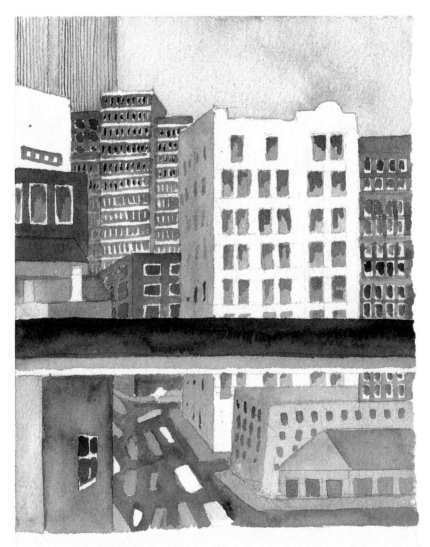

LOOKING SOUTH DOWN CHURCH FROM SILRIDS 2/4/01 5PM

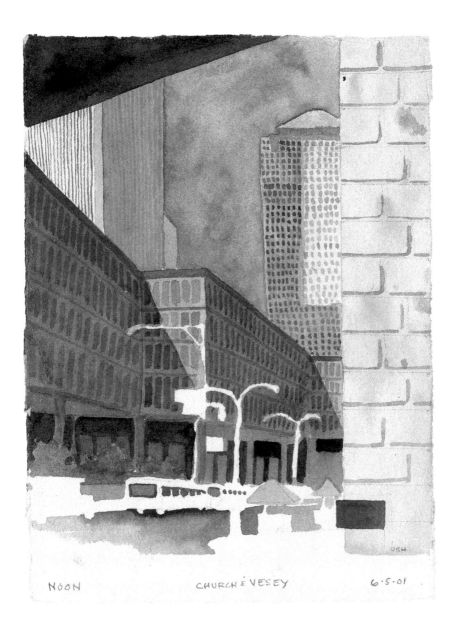

NOON CHURCH & VESEY 6·5·01

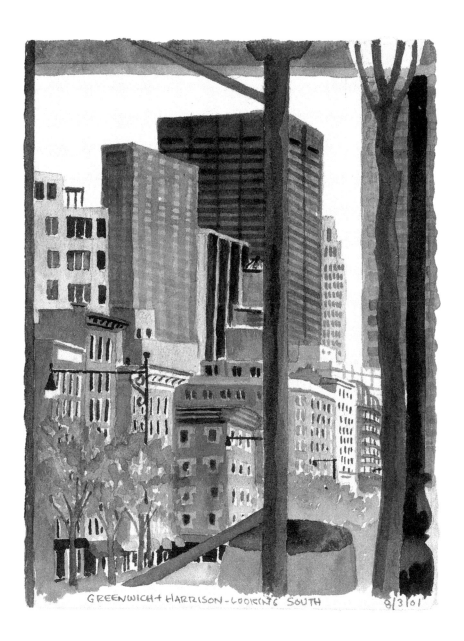

GREENWICH + HARRISON - LOOKING SOUTH 8/3/01

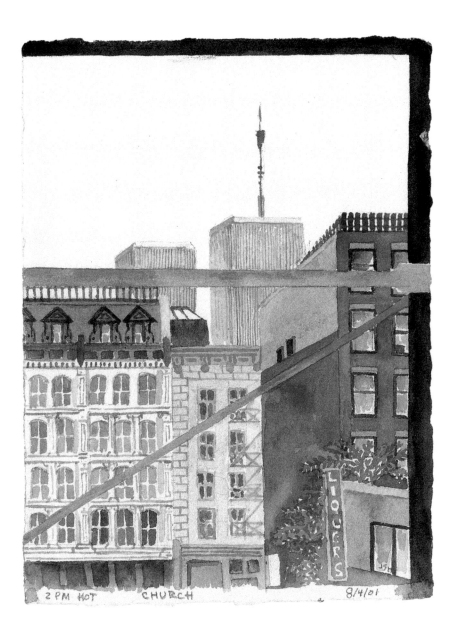

2 PM HOT CHURCH 8/4/01

9

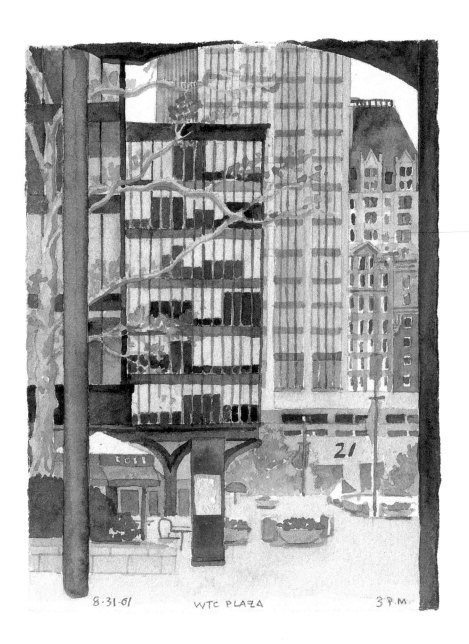

8·31·01 WTC PLAZA 3 P.M

On September 26, 2001, we were allowed to go home.
We had fled reluctantly, with only the cats, late on the afternoon
of the 11th. The Towers were down; a third building was
lighting up with fire two blocks to the south.

The intervening two weeks had been an agonizing ordeal; first
trying to ascertain whether we still had a home at all,
then begging for access to retrieve the prescriptions,
checkbooks, and watercolors abandoned in our flight. We
wondered at how fortunate we were to have survived so relatively
unscathed.

For almost a month, we were in the Red Zone, fenced in with the
smoldering ruins of the World Trade Center complex, and
although I was never in what is called Ground Zero, its harrowing
and hallowed influence was all around.

As what I now see was an instinctive coping device, I drew.
To me the buildings were still there, horribly changed, true, but as
intrinsically a part of my daily life as they had been intact.

I clung to the ruins because they seemed more familiar than the
new and disorienting vistas and light patterns opening up all
around the neighborhood I've lived in for twenty-seven years.

When the last vestiges of the North Tower were dismantled,
my need to draw the site ended. What had begun as a chronicle of
destruction became, at last, an odyssey toward acceptance.

Jean Holabird

William Wordsworth

THE PRELUDE

…but after I had seen
That spectacle, for many days, my brain
Worked with a dim and undetermined sense
Of unknown modes of being; o'er my thoughts
There hung a darkness, call it solitude
Or blank desertion. No familiar shapes
Remained, no pleasant images of trees,
Or sea or sky, no colours of green fields;
But huge and mighty forms, that do not live
Like living men, moved slowly through the mind
By day, and were a trouble to my dreams.

excerpt

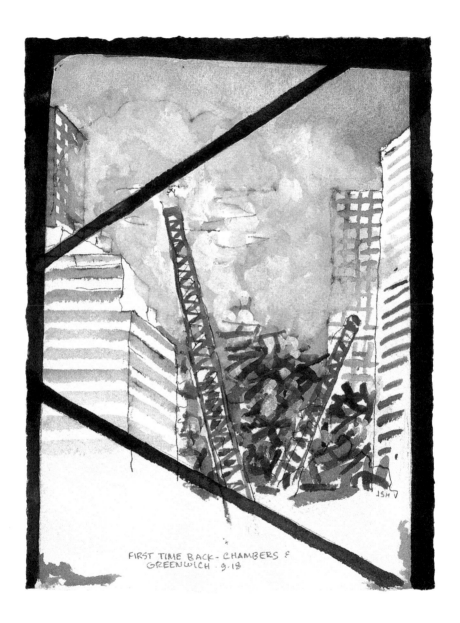

FIRST TIME BACK - CHAMBERS &
GREENWICH · 9·18

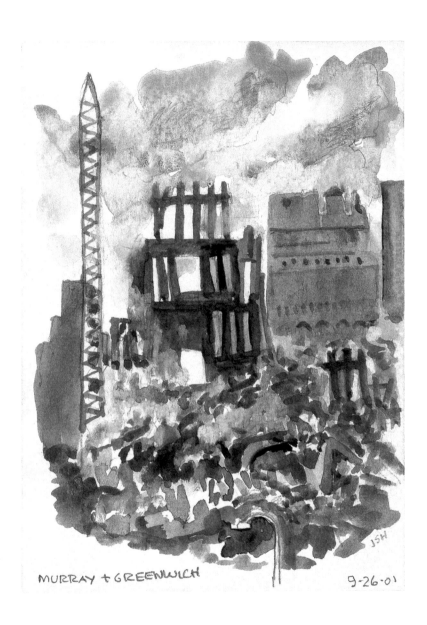

MURRAY + GREENWICH 9-26-01

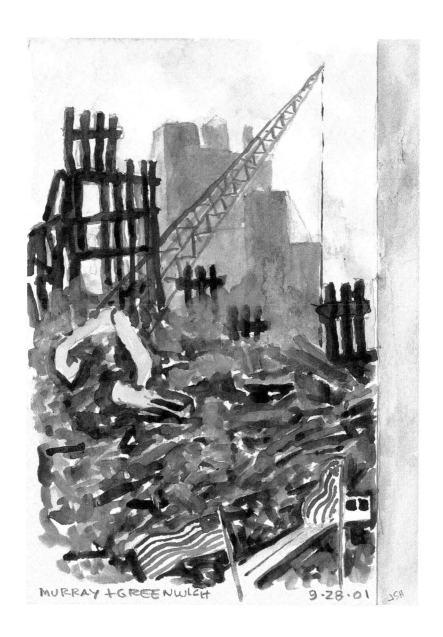

MURRAY + GREENWICH 9·28·01 JSH

Percy Bysshe Shelley

OZYMANDIAS

I met a traveller from an antique land
Who said: Two vast and trunkless legs of stone
Stand in the desert. Near them, on the sand,
Half sunk, a shattered visage lies, whose frown,
And wrinkled lip, and sneer of cold command,
Tell that its sculptor well those passions read
Which yet survive, stamped on those lifeless things,
The hand that mocked them, and the heart that fed;
And on the pedestal these words appear:
"My name is Ozymandias, king of kings:
Look on my works, ye Mighty, and despair!"
Nothing beside remains. Round the decay
Of that colossal wreck, boundless and bare
The lone and level sands stretch far away.

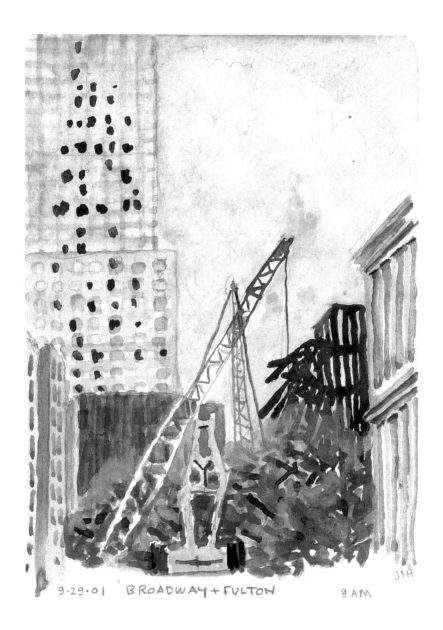

9·29·01 BROADWAY + FULTON 9 AM

JSH

Richard Wright

The blue of this sky
Sounds so loud that it can be heard
Only with our eyes.

Hart Crane

THE BROKEN TOWER

And so it was I entered the broken world
To trace the visionary company of love, its voice
An instant in the wind (I know not whither hurled)
But not for long to hold each desperate choice.

excerpt

Dante

THE DIVINE COMEDY, Canto XXXI

Turning our back upon the vale of woe,
We cross'd the encircled mound in silence...

* * *

Thitherward not long
My head was rais'd, when many lofty towers
Methought I spied. "Master," said I, "what land
Is this?" He answer'd straight: "Too long a space
Of intervening darkness has thine eye
To traverse: thou hast therefore widely err'd
In thy imagining. Thither arriv'd
Thou well shalt see, how distance can delude
The sense...

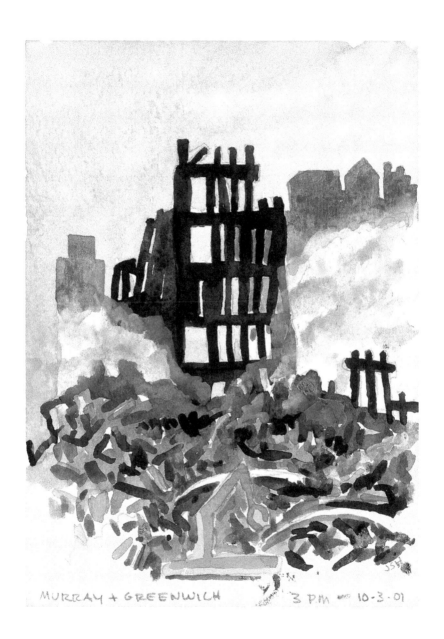

MURRAY + GREENWICH 3 P.M 10-3-01

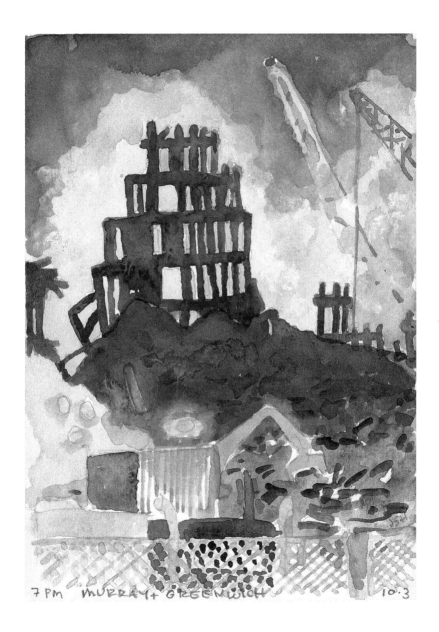

7 PM MURRAY + GREENWICH 10.3

Edgar Allan Poe

TO ONE IN PARADISE

Ah, dream too bright to last!
 Ah starry Hope! that didst arise—
But to be overcast!
 A voice from out the Future cries,
"On, on!" But o'er the Past
 (Dim gulf!) my spirit hovering lies
Mute, motionless, aghast!

excerpt

Emily Dickinson

THE FIRST DAY'S NIGHT HAD COME

The first Day's Night had come—
And grateful that a thing
So terrible—had been endured—
I told my Soul to sing—

She said her Strings were snapt—
Her Bow—to Atoms blown—
And so to mend her—gave me work—
Until another Morn—

And then—a Day as huge—
As Yesterdays in pairs,
Unrolled it's horror in my face—
Until it blocked my eyes—

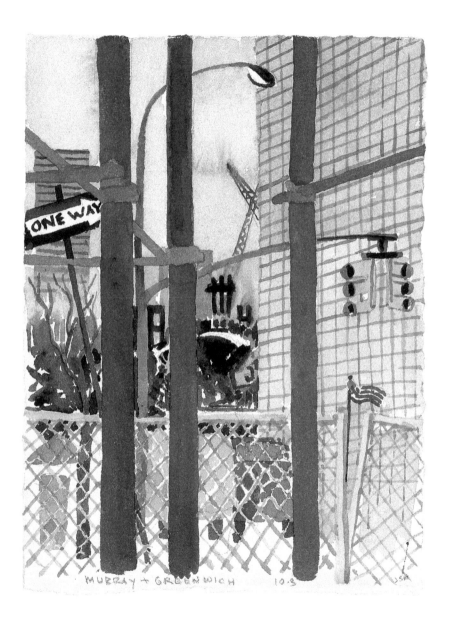

MURRAY + GREENWICH 10·8

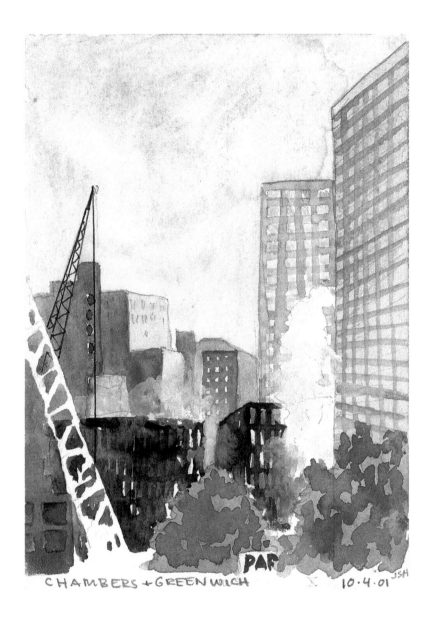

CHAMBERS + GREENWICH 10·4·01 JSH

Octavio Paz

WORDS IN THE SHAPE OF
A CLOUD OF DUST

I open the window
 that looks out
on nowhere
 the window
that looks in
 The wind
raises
 sudden weightless
towers of whirling dust

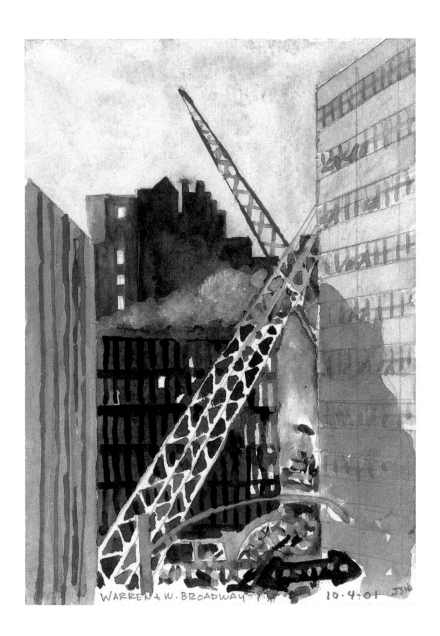

WARREN + W. BROADWAY 10·4·01 JS14

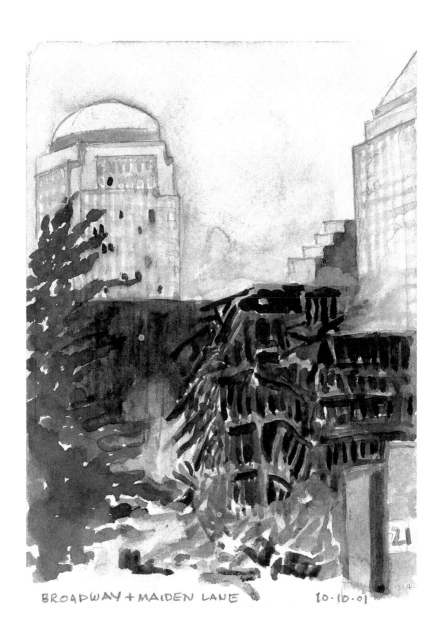

BROADWAY + MAIDEN LANE 10·10·01

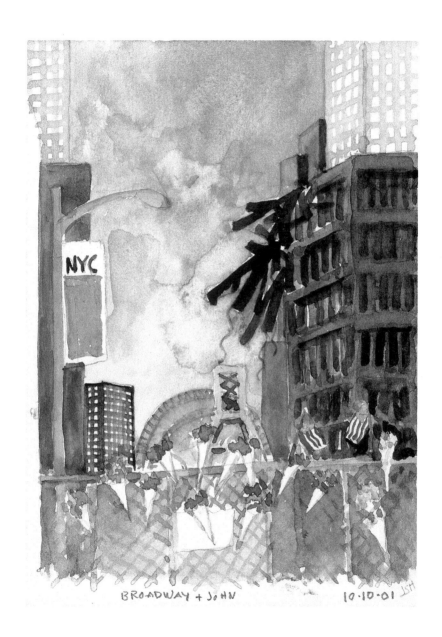

BROADWAY + JOHN 10·10·01 JSH

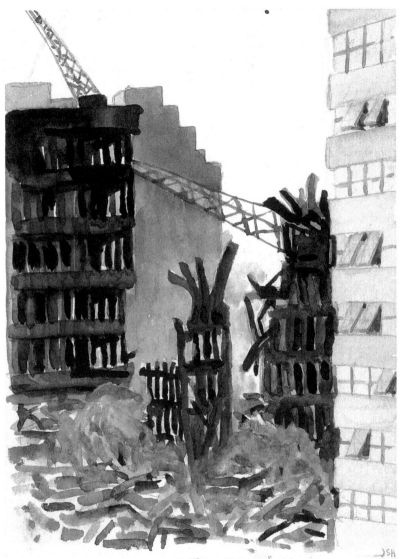

MURRAY ✦ WEST BROADWAY 10·10·01

Seamus Heaney

CLEARANCES

And we all knew one thing by being there.
The space we stood around had been emptied
Into us to keep, it penetrated
Clearances that suddenly stood open.
High cries were felled and a pure change happened.

excerpt

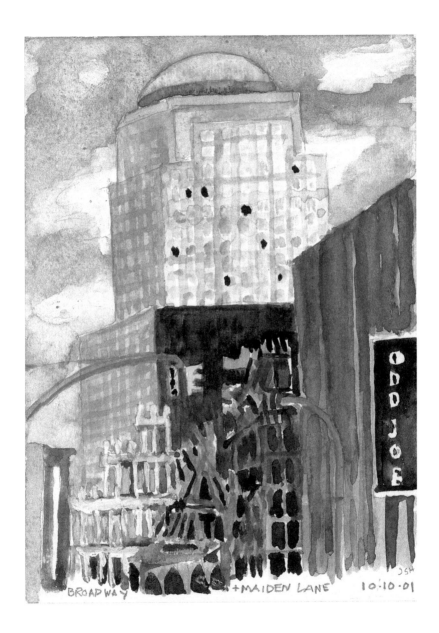

BROADWAY +MAIDEN LANE 10·10·01

ODD JOE

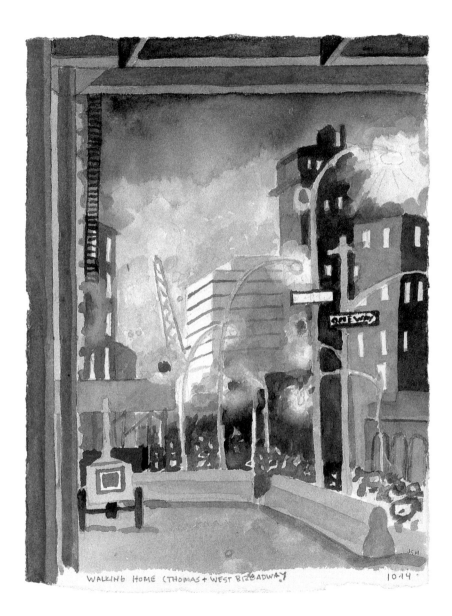

WALKING HOME (THOMAS + WEST BROADWAY) 10·14

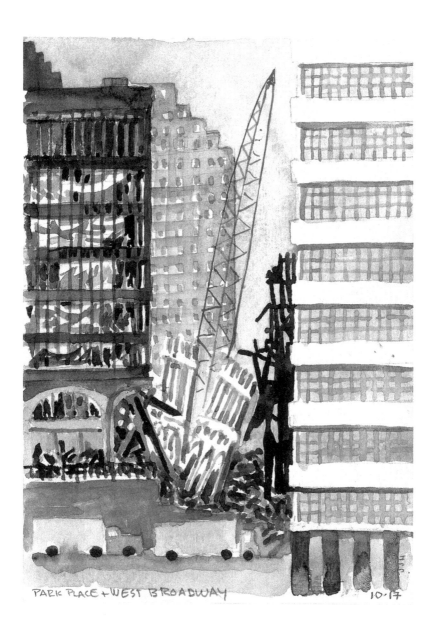

PARK PLACE + WEST BROADWAY 10·17

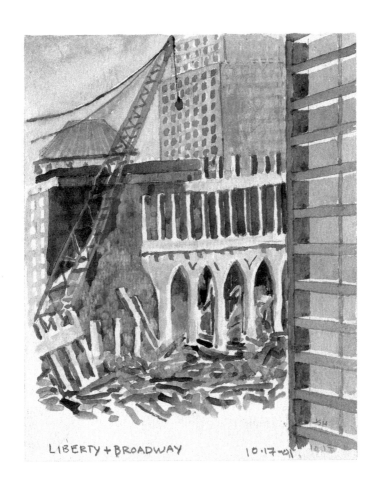

LIBERTY + BROADWAY 10·17-01

John Milton

PARADISE LOST

...And here let those
Who boast in mortal things, and wondering tell
Of Babel, and the works of Memphian kings,
Learn how their greatest monuments of fame
And strength, and art, are easily outdone
By Spirits reprobate, and in an hour
What in an age they, with incessant toil
And hands innumerable, scarce perform.

excerpt

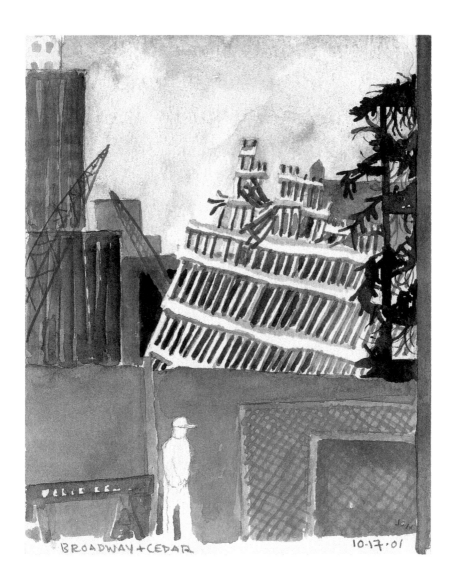

BROADWAY + CEDAR 10·17·01

47

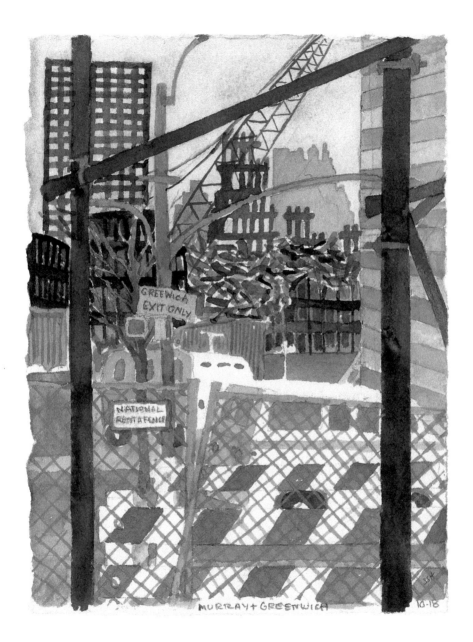

GREEWICH
EXIT ONLY

NATIONAL
RENT A FENCE

MURRAY + GREENWICH 10-18

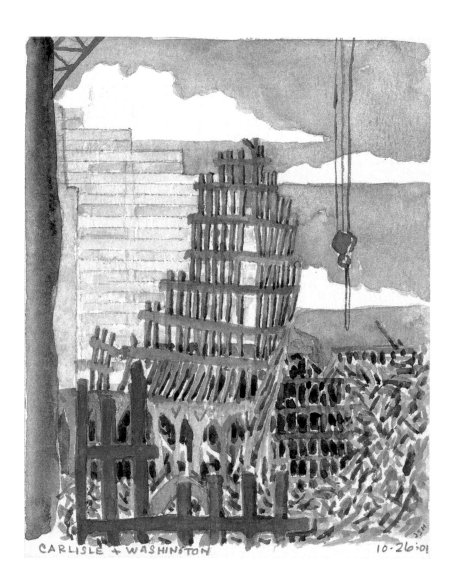

CARLISLE + WASHINGTON 10-26-01

Edgar Allan Poe

THE CITY IN THE SEA

But lo, a stir is in the air!
The wave—there is a movement there!
As if the towers had thrust aside,
In slightly sinking, the dull tide—
As if their tops had feebly given—
A void within the filmy Heaven.
The waves have now a redder glow
The hours are breathing faint and low
And when, amid no earthly moans,
Down, down that town shall settle hence,
Hell, rising from a thousand thrones,
Shall do it reverence.

excerpt

Swinburne

LAUS VENERIS

There is no change of cheer for many days,
But change of chimes high up in the air, that sways
 Rung by the running fingers of the wind;
And singing sorrows heard on hidden ways.

excerpt

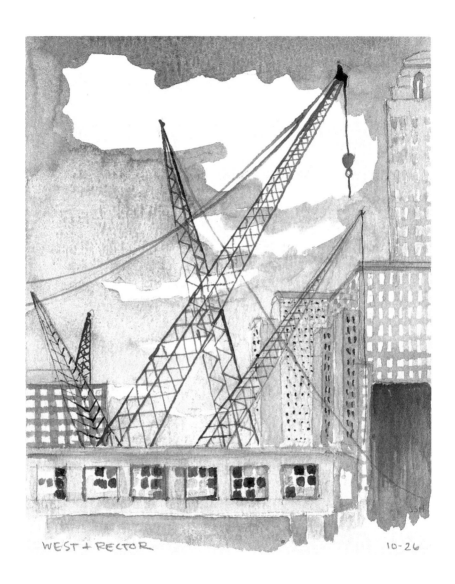

WEST & RECTOR

10-26

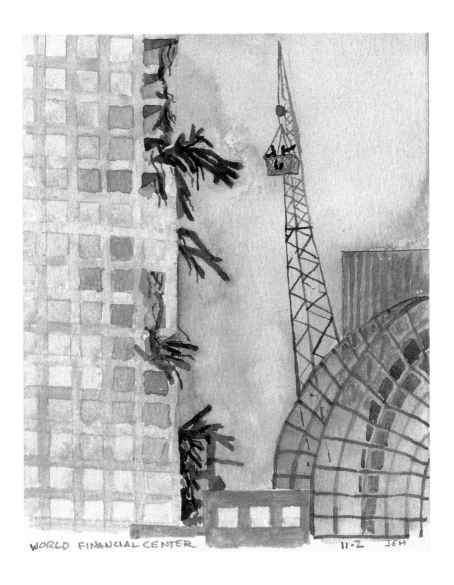

WORLD FINANCIAL CENTER 11·2 JSH

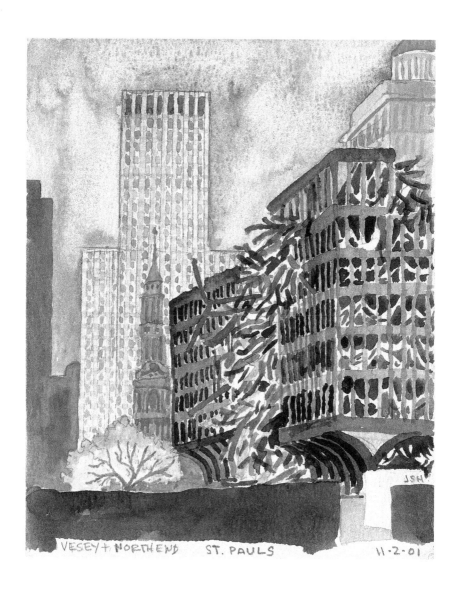

VESEY + NORTHEND ST. PAULS 11·2·01

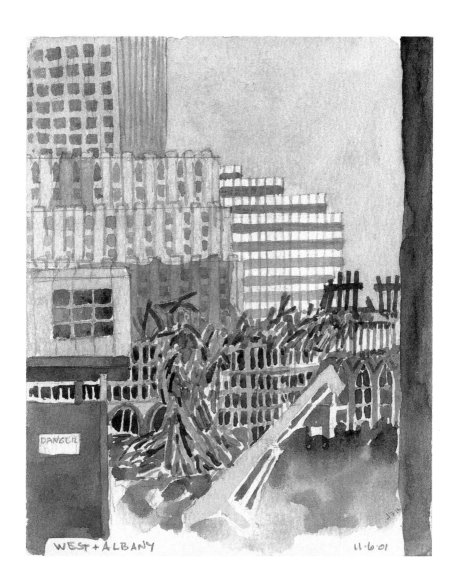

DANGER

WEST + ALBANY 11·6·01

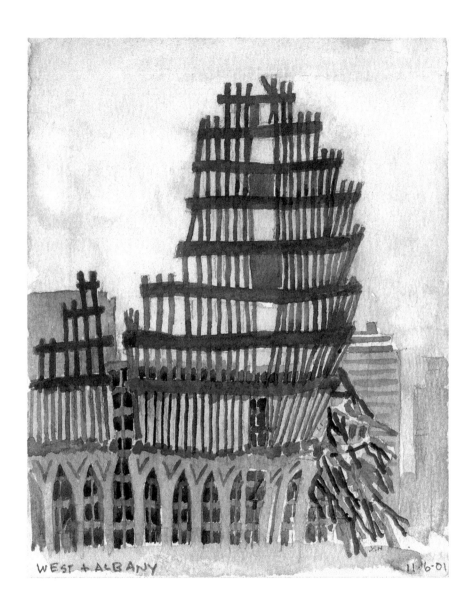

WEST + ALBANY 11·6·01

Pablo Neruda

KEEPING QUIET

Now we will count to twelve
and we will all keep still

For once on the face of the earth,
let's not speak in any language;
let's stop for a second,
and not move our arms so much.

It would be an exotic moment
without rush, without engines;
we would all be together
in a sudden strangeness.

Those who prepare green wars,
wars with gas, wars with fire,
victories with no survivors,
would put on clean clothes
and walk about with their brothers
in the shade, doing nothing.

What I want should not be confused
with total inactivity.
Life is what it is about;
I want no truck with death.

If we were not so single-minded
about keeping our lives moving,
and for once could do nothing,
perhaps a huge silence
might interrupt this sadness
of never understanding ourselves
and of threatening ourselves with death.
Perhaps even the earth can teach us
as when everything seems to be dead in winter
and later proves to be alive.

Now I'll count up to twelve
and you keep quiet and I will go.

T.S. Eliot

LITTLE GIDDING

Ash on an old man's sleeve
Is all the ash the burnt roses leave.
Dust in the air suspended
Marks the place where a story ended.
Dust inbreathed was a house
The wall, the wainscot and the mouse
The death of hope and despair,
 This is the death of air.

excerpt

Richard Wright

This autumn drizzle
is our bond with other eyes
That can see no more.

Swinburne

LAUS VENERIS

For if mine eyes fail and my soul takes breath,
I look between the iron sides of death
 Into sad hell where all sweet love hath end,
All but the pain that never finisheth

excerpt

John Milton

PARADISE LOST

Seest thou yon dreary plain, forlorn and wild,
The seat of desolation, void of light,
Save what the glimmering of these livid flames
Casts pale and dreadful? Thither let us tend
From off the tossing of these fiery waves;
There rest, if any rest can harbour there;
And, re-assembling our afflicted powers,
Consult how we may henceforth most offend
Our enemy, our own loss how repair,
How overcome this dire calamity,
What reinforcement we may gain from hope,
If not, what resolution from despair.

excerpt

Sidney Lanier

THE RAVEN DAYS

Our hearths are gone out, and our hearts are broken,
 And but the ghosts of homes to us remain,
And ghostly eyes and hollow sighs give token
 From friend to friend of an unspoken pain.

* * *

O Raven days, dark Raven Days of sorrow,
 Will ever any warm light come again?
Will ever the lit mountains of To-morrow
 Begin to gleam across the mournful plain?

excerpt

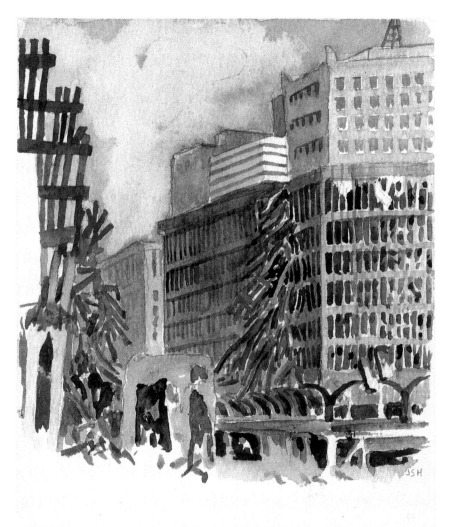

WEST + ALBANY 11·6·01

Herman Melville

MISGIVINGS

When ocean-clouds over inland hills
Sweep storming in late autumn brown,
And horror the sodden valley fills,
And the spire falls crashing in the town,
I muse upon my country's ills—
The tempest bursting from the waste of Time
On the world's fairest hope linked with man's foulest
crime.

Nature's dark side is heeded now—
(Ah! optimist-cheer disheartened flown)—
A child may read the moody brow
Of yon black mountain lone.
With shouts the torrents down the gorges go,
And storms are formed behind the storms we feel:
The hemlock shakes in the rafter, the oak in the driving
keel.

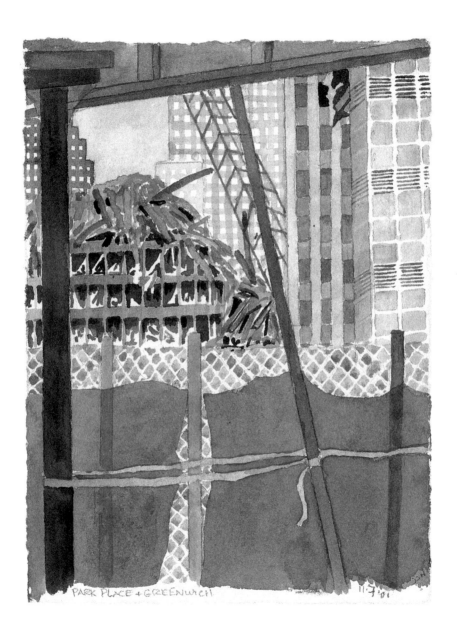

PARK PLACE + GREENWICH 11·7·01

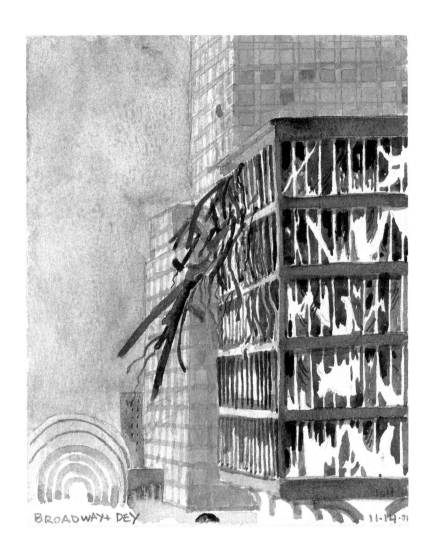

BROADWAY + DEY 11·14·91

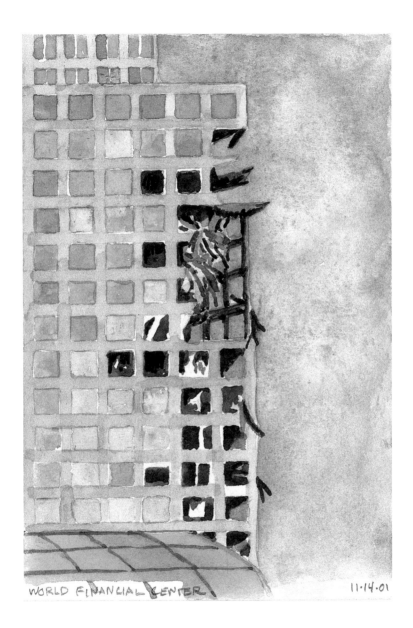

WORLD FINANCIAL CENTER 11·14·01

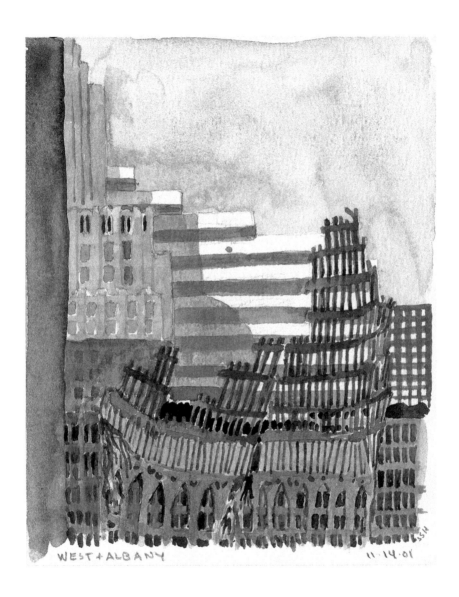

WEST & ALBANY 11-14-01

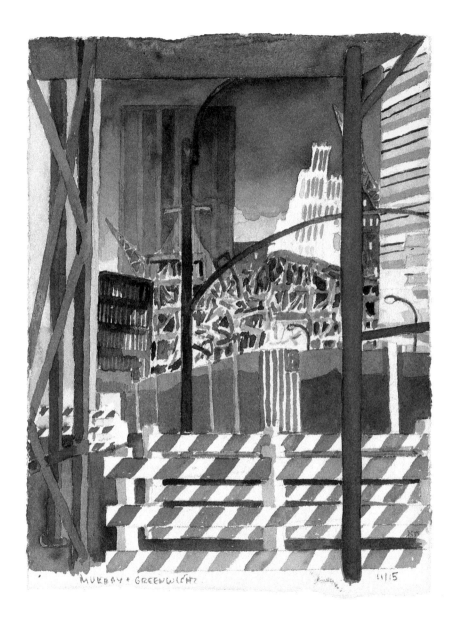

MURRAY + GREENWICH 11/15

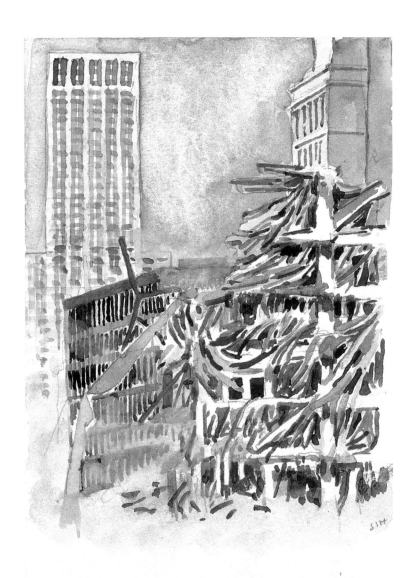

NORTH END + VESEY 11·19·01

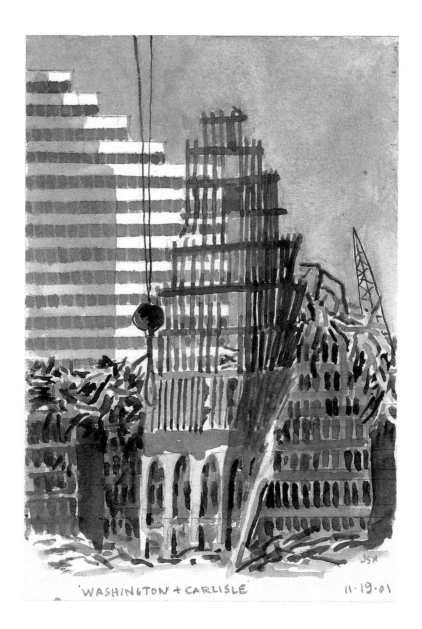

'WASHINGTON + CARLISLE' 11·19·01

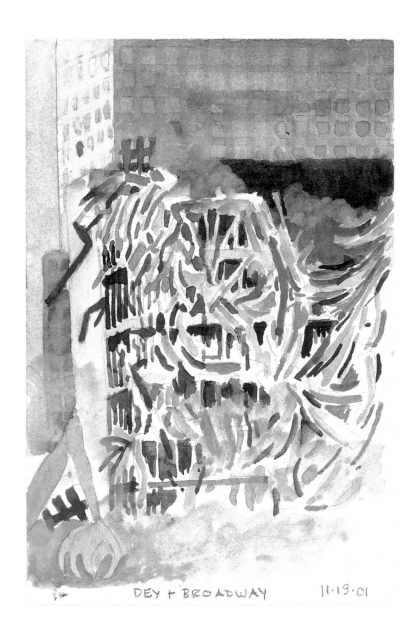

DEY + BROADWAY 11·19·01

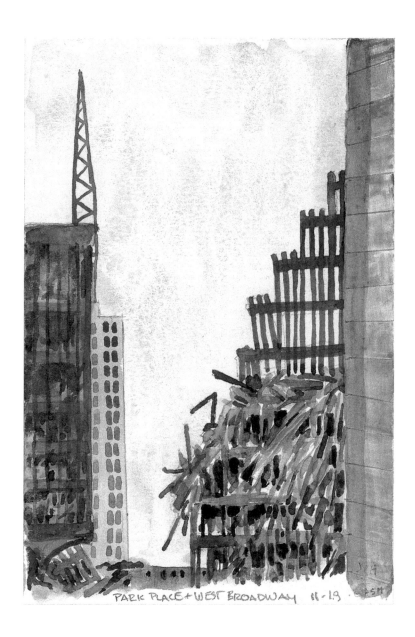

PARK PLACE + WEST BROADWAY 11-19 ASH

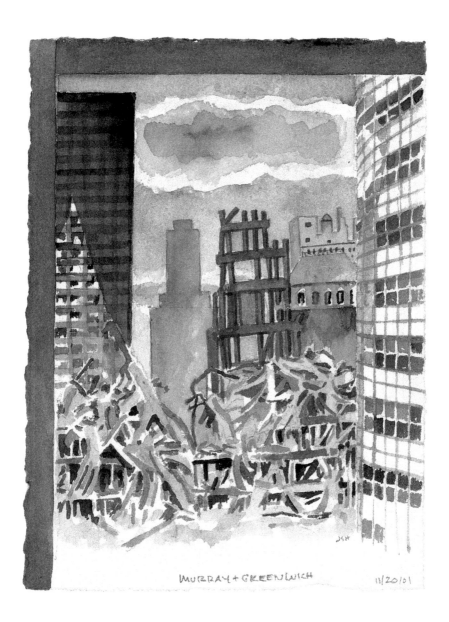

MURRAY + GREENWICH 11/20/01

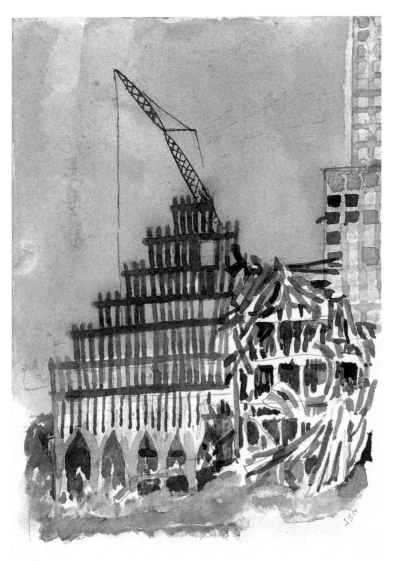

BROADWAY + FULTON 11-29-01

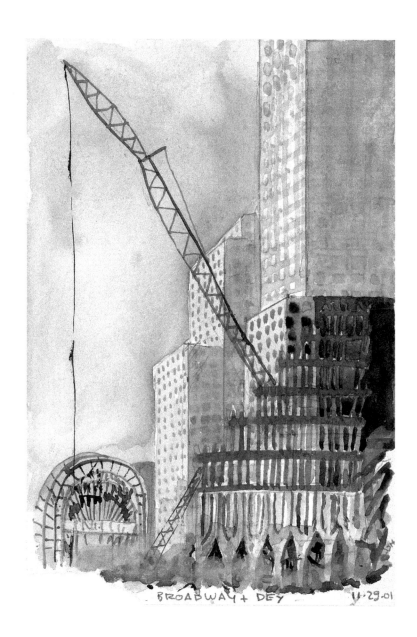

BROADWAY + DEY 11-29-01

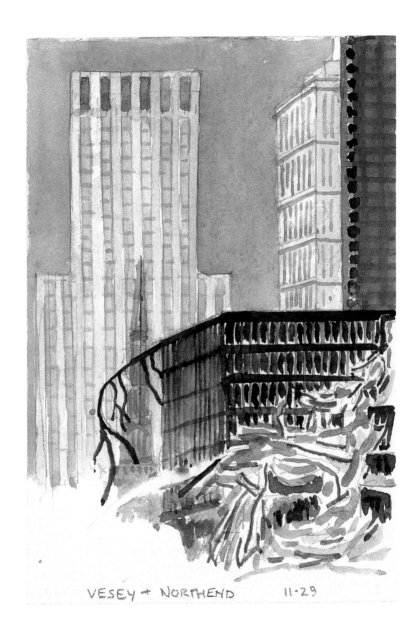

VESEY + NORTHEND 11-29

Richard Wright

I feel autumn rain
Trying to explain something
I do not want to know.

T.S. Eliot

BURNT NORTON

Time and the bell have buried the day,
The black cloud carries the sun away.

excerpt

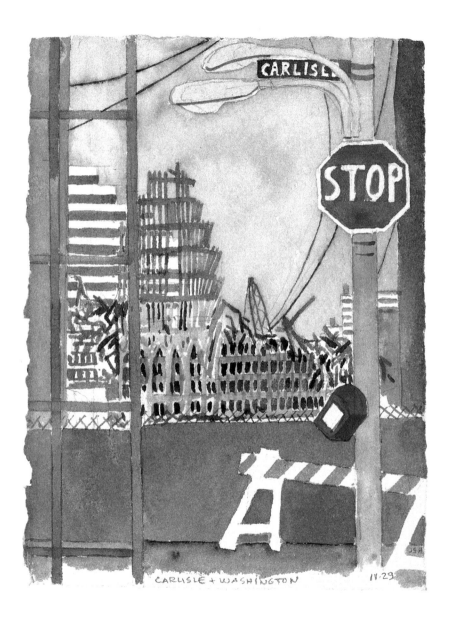

CARLISLE + WASHINGTON 11·29

Conrad Aiken

TIME IN THE ROCK

O Patience, let us be patient and discern
In this lost leaf all that can be discerned:
And let us learn, from this sad violence learn,
All that in the midst of violence can be learned.

excerpt

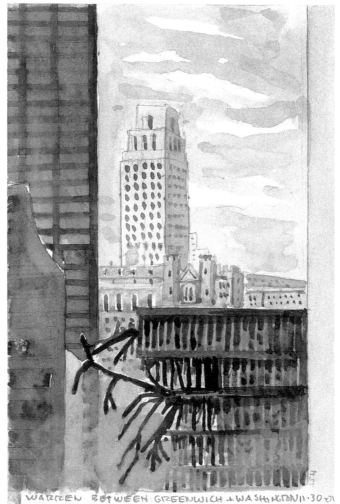

WARREN BETWEEN GREENWICH + WASHINGTON 11·30·01

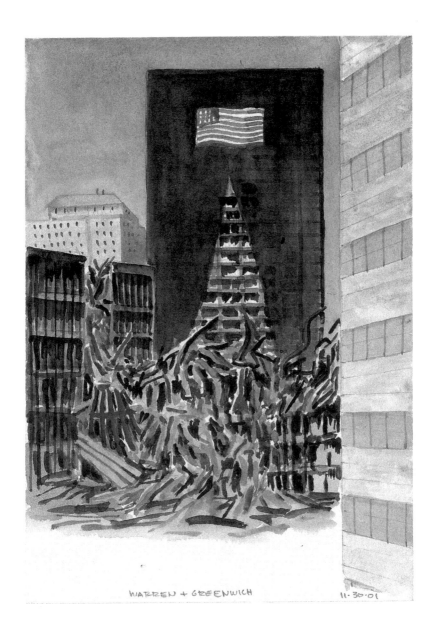

WARREN + GREENWICH 11·30·01

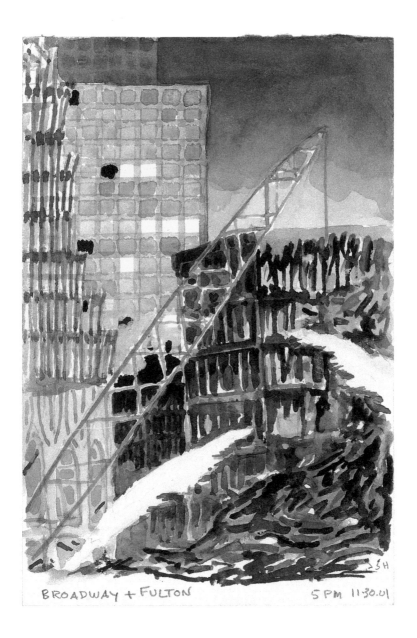

BROADWAY + FULTON 5 PM 11·30·01

James Thomson

THE CITY OF DREADFUL NIGHT

Yes, here and there some weary wanderer
 In that same city of tremendous night
Will understand the speech, and feel a stir
 Of fellowship in all-disastrous flight;

<div align="center">* * *</div>

For life is but a dream whose shapes return,
 Some frequently, some seldom, some by night
And some by day, some night and day: we learn,
 The while all change and many vanish quite,
In their recurrence with recurrent changes
A certain seeming order; where this ranges
 We count things real; such is memory's might.

excerpts

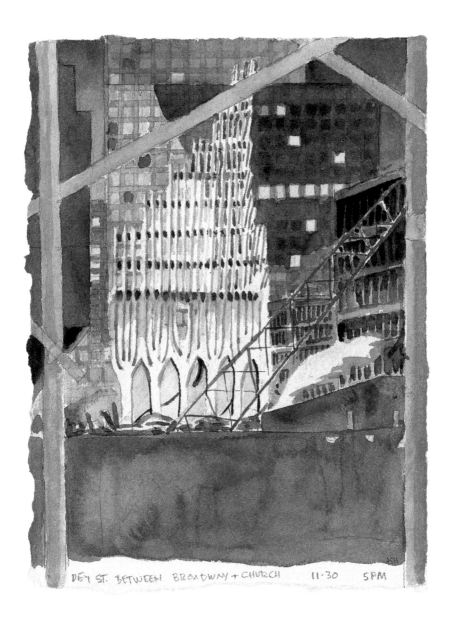

DEY ST. BETWEEN BROADWAY + CHURCH 11·30 5PM

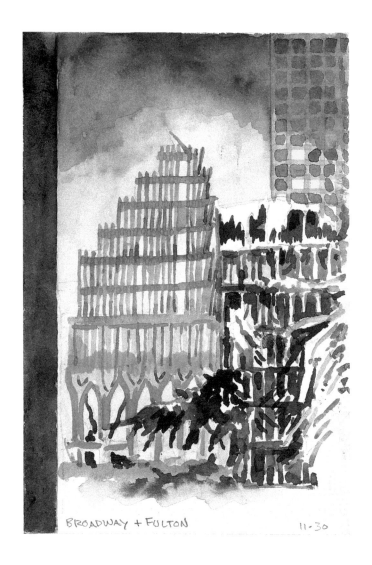

BROADWAY + FULTON 11-30

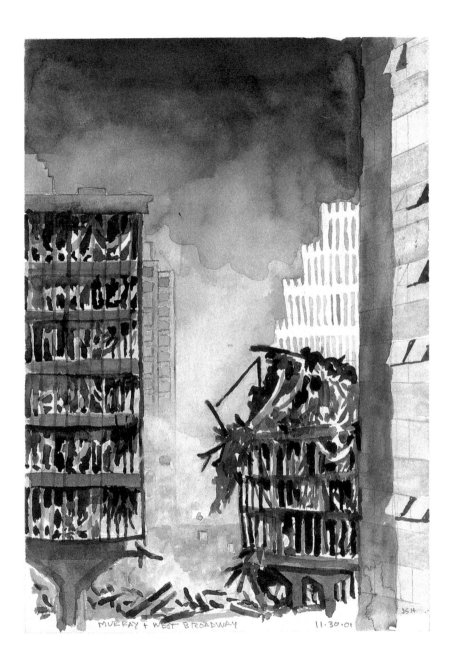

MURRAY + WEST BROADWAY 11·30·01

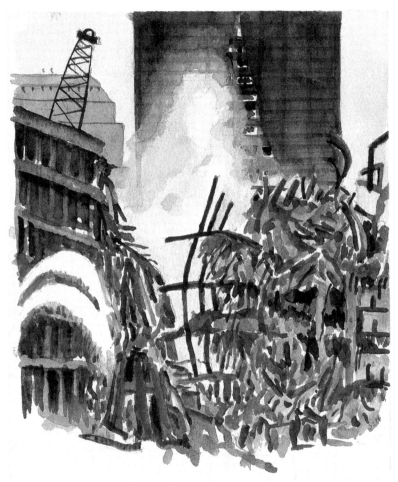

WARREN + GREENWICH 12-1-01

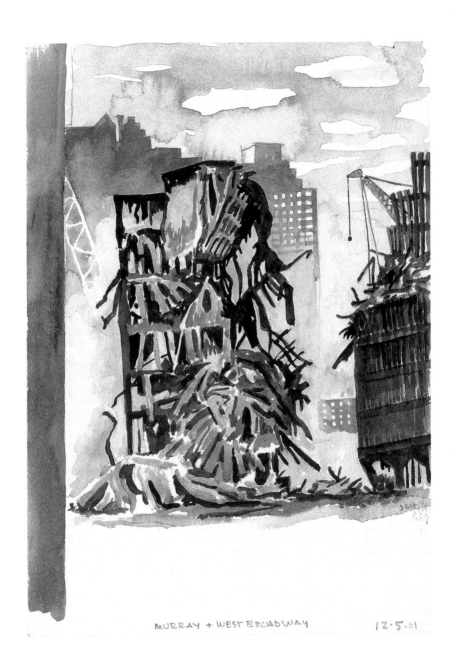

MURRAY + WEST BROADWAY 12·5·01

Emily Dickinson

AFTER GREAT PAIN,
A FORMAL FEELING COMES

After great pain, a formal feeling comes—
The Nerves sit ceremonious, like Tombs—
The stiff Heart questions was it He, that bore,
And Yesterday, or Centuries before?

The Feet, mechanical, go round—
Of Ground, or Air, or Ought—
A Wooden way
Regardless grown,
A Quartz contentment, like a stone—

This is the Hour of Lead—
Remembered, if outlived,
As Freezing persons, recollect the Snow—
First—Chill—then Stupor—then the letting go—

T. S. Eliot

BURNT NORTON

At the still point of the turning world. Neither flesh nor
 fleshless;
Neither from nor towards; at the still point, there the dance
 is,
But neither arrest nor movement. And do not call it fixity,
Where past and future are gathered. Neither movement
 from nor towards,
Neither ascent nor decline. Except for the point, the still
 point,
There would be no dance, and there is only the dance.

excerpt

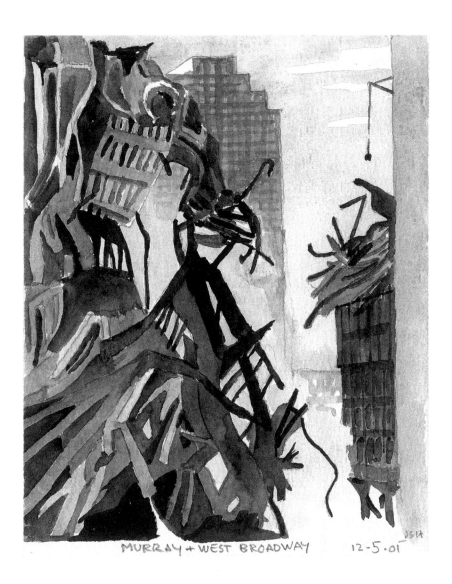

MURRAY + WEST BROADWAY 12-5-01

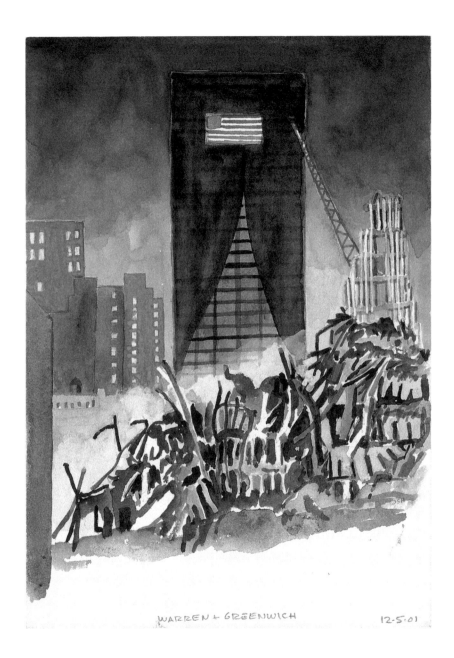

WARREN & GREENWICH 12-5-01

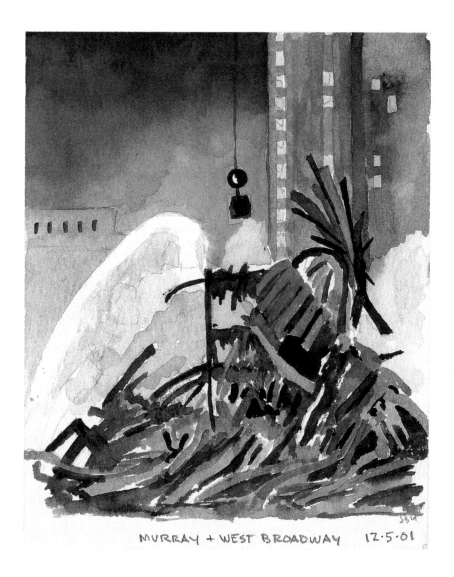

MURRAY + WEST BROADWAY 12·5·01

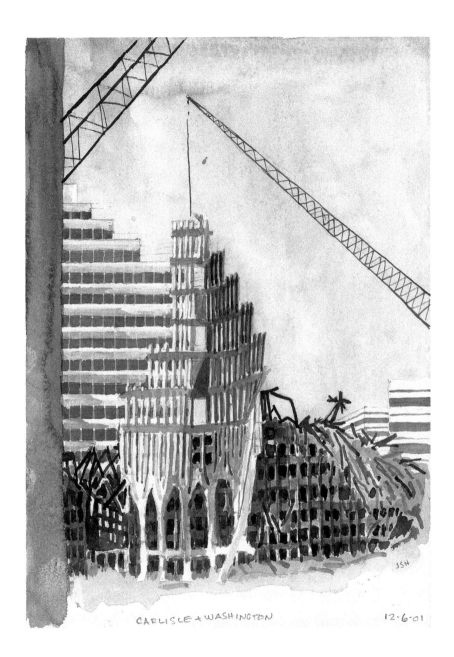

CARLISLE + WASHINGTON 12·6·01

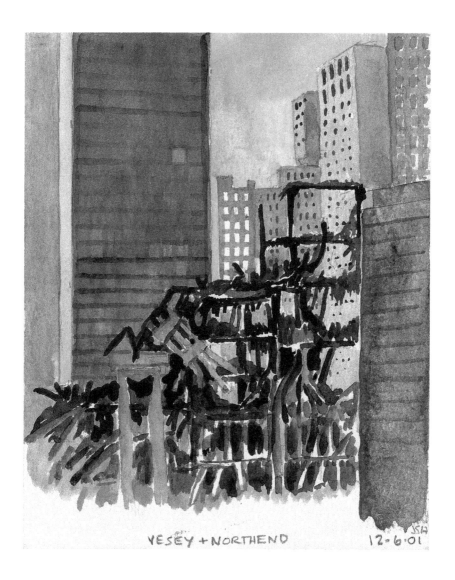

VESEY + NORTHEND 12-6-01 JSH

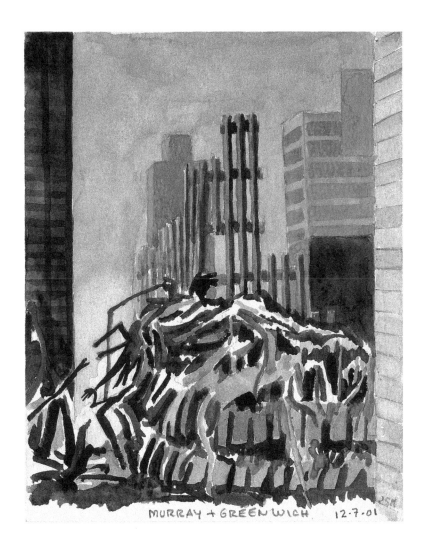

MURRAY + GREENWICH 12·7·01

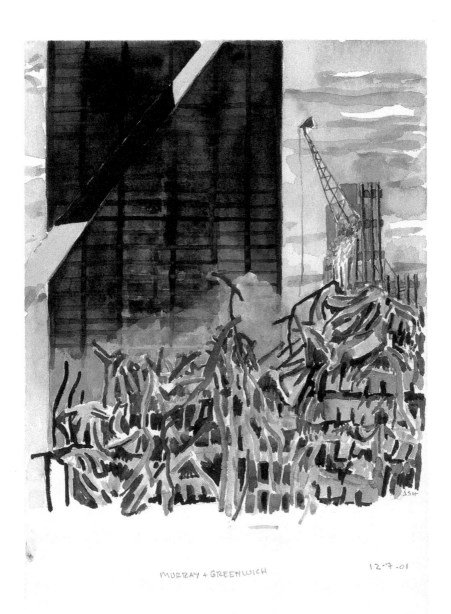

MURRAY + GREENWICH 12-7-01

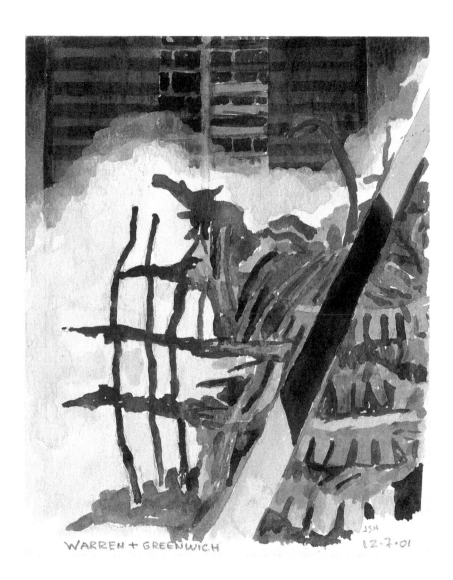

WARREN + GREENWICH

JSH
12·7·01

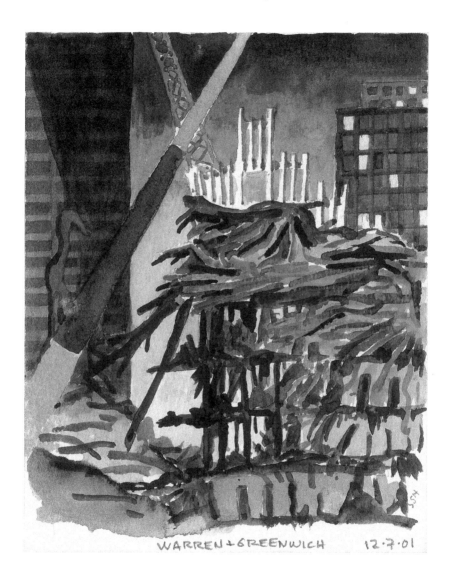

WARREN + GREENWICH 12·7·01

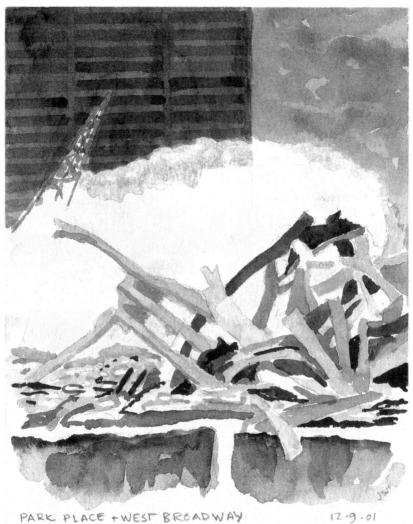

PARK PLACE + WEST BROADWAY 12·9·01

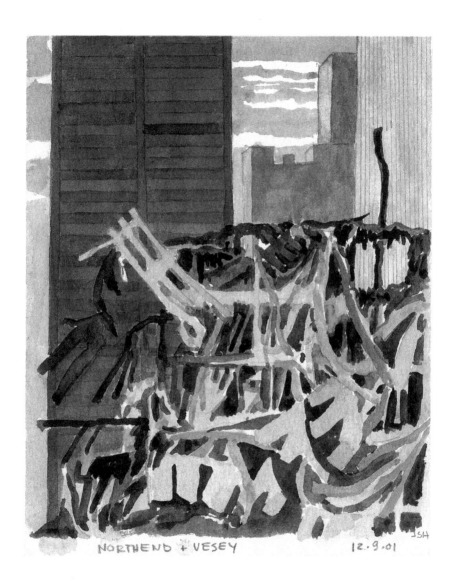

NORTHEND + VESEY 12.9.01

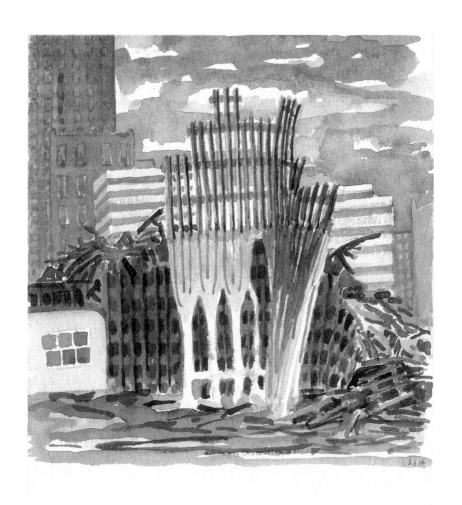

ALBANY + SOUTHEND 12·9·01

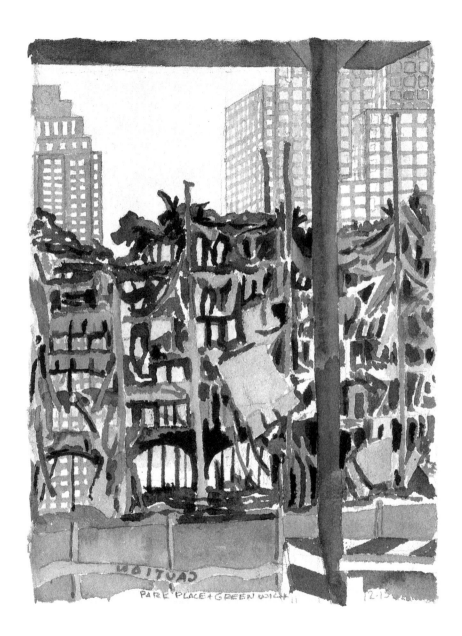

CAUTION

PARK PLACE + GREENWICH 12-13

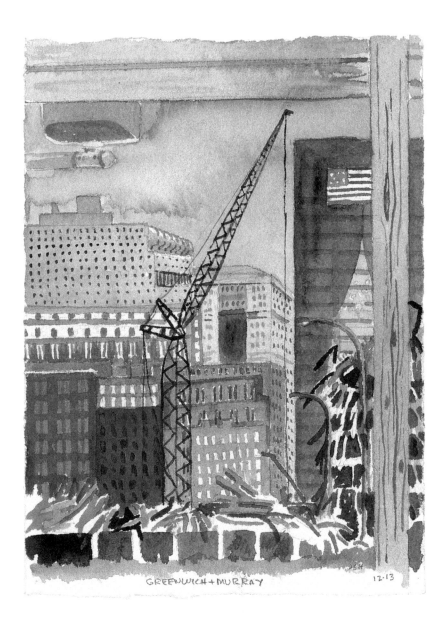

GREENWICH + MURRAY 12·13

Thomas Wolfe

LOOK HOMEWARD, ANGEL!

O waste of loss, in the hot mazes, lost, among bright stars on this most weary unbright cinder, lost! Remembering speechlessly we seek the great forgotten language, the lost lane-end into heaven, a stone, a leaf, an unfound door. Where? When? O lost, and by the wind grieved, ghost, come back again.

excerpt

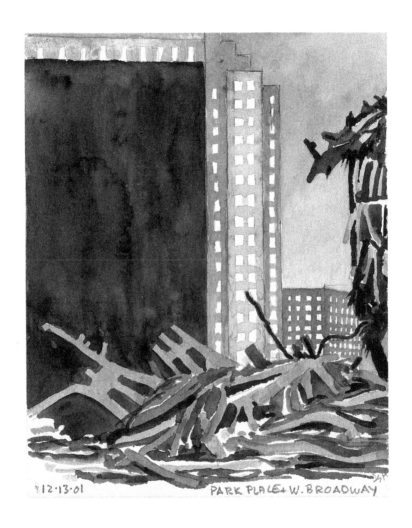

12·13·01 PARK PLACE + W. BROADWAY

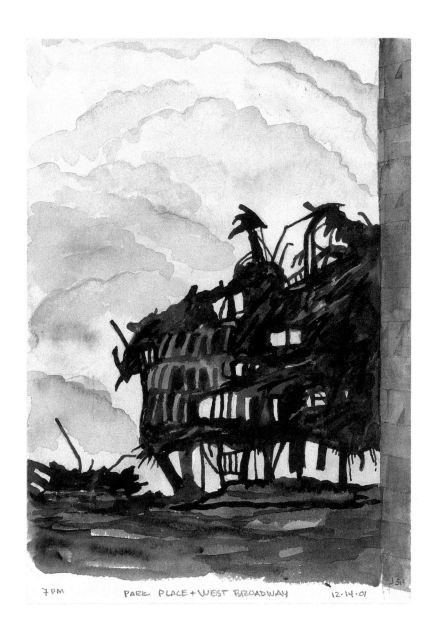

7 PM PARK PLACE + WEST BROADWAY 12·14·01

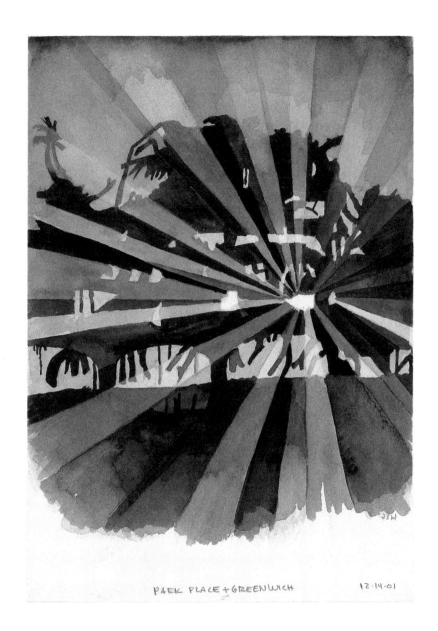

PARK PLACE + GREENWICH 12·14·01

Walt Whitman

CITY OF SHIPS

City of the World! (for all races are here.
All the lands of the earth make contributions here;)

City of the sea!....

. . . .

City of wharves and stores—city of tall façades of
marble and iron!
Proud and passionate city—mettlesome, mad,
extravagant city!

Frank O'Hara

MEDITATIONS IN AN EMERGENCY

One need never leave the confines of New York to get
all the greenery one wishes—I can't even enjoy a
blade of grass unless I know there's a subway handy or a
record store or some other sign that people do not
totally regret life.

Inscribed at World Financial Center, North Harbor.

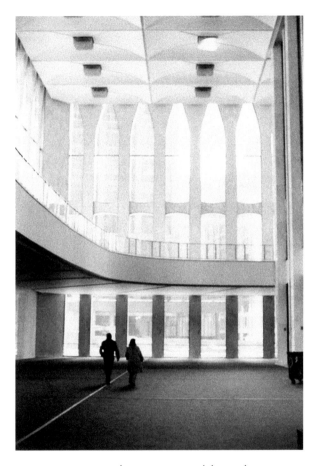

Mezzanine, North Tower, World Trade Center
Photograph by Gus Speer, © 1974

Jean Holabird was born in Cambridge, Massachusetts, grew up in Chicago, and studied at Columbia University, The Art Students League, and Bennington College. As with many of her fellow artists, she fell in love with New York City. In 1975 she moved into her present studio on Warren Street, in lower Manhattan, four blocks north of the World Trade Center.

The Artist Jean Holabird
interviewed by Donna Wiemann

Why do you use watercolors?

JH: I had been working primarily in oil until I moved to Warren Street.
The loft needed a lot of work, there was no room to set up large
canvasses, so I used watercolor in the interim. Although I went back
to painting in oils later, the watercolors had become more suitable
for my work. I like them because they are portable.

In January 2001, you began your project of painting "a window a day".
Why did you choose windows as a subject?

JH: The "window a day" project was devised as a discipline, to
keep me looking and working. I have always been attracted to
windows because they form a natural frame within which to
compose. Many of my oils involve windows, too. After September 11
the scaffolding throughout the neighborhood provided "frames"
or "windows" from which to capture the constantly changing vistas,
but my need to draw was too intense to limit them to one a day.

When did you start to sketch the first images?

JH: On the first of my fleeting returns home to get my checkbook
or something, I happened to have paper in my bag, I had to record
my first sight of the ruins. The biggest problem was orientation;

there was so much scaffolding about, not to mention machinery and various barriers, that the most familiar streets seemed like some other planet. The ruins became familiar, a point of reference, and came to represent, I see now, the complex itself.

I had to stay on the perimeter because Ground Zero was off-limits to all but the workers, the government and the VIPs. I would skirt the ever-changing boundaries and seek what vantage points I could. I fantasized about getting in, but it felt wrong to me, and at some point I saw that I could only record my own experience.

Would your pictures have been different had you gone into Ground Zero?

JH: Yes, I think, very, but I'll never know how.

Did you feel that as a neighborhood resident and affected citizen you had a right to view the destruction at Ground Zero first hand?

JH: It would have been impossible to allow access to all those who witnessed the catastrophe first hand. I never stopped thinking about the human carnage, and I feel that it was right, after all, to limit entry. It is hallowed ground, and I don't think I would have been able to draw there anyway, it would have been too upsetting.

You have made a chronological series of sketches that follow the tearing apart and removal of the rubble. There is no doubt that these pictures are beautiful even though they reflect something sinister. What are you trying to communicate?

JH: I was really trying to communicate the reality of it to myself.

I was particularly struck by the contrast between the intact buildings surrounding the site, and the destruction within. It had changed every time I went out to draw. I wanted to show that. Rather than denying the dark nature of the events, I saw irony in the awful beauty the ruins presented. At night, there was a ghastly light that was stunning and grim, yet somehow spiritual. I find the pictures haunting, even now. I can hardly believe that I saw what I saw. This is my way of letting you see it, too.

Where were you when the attacks took place?

JH: It was rush hour, so we were accustomed to hearing the traffic helicopters at that hour. I was in the kitchen. My loft is on the top floor. We heard the first plane flying low right overhead, and then a dull thud. I thought a helicopter had crashed, until I looked up and saw the outline of a plane in the side of the north tower. The smoke was curling up all along the sides. A few minutes later we heard the second plane. By then the TV was on. Panes of glass were swirling in the smoke outside the window, and I think we went into shock.

We live very close, and thought the towers would surely fall on us, or at least some of the debris would come crashing through the skylight. We had no way of knowing that they would implode. After we heard the first building go, we grabbed the cats and ran down the stairs to the first floor of the hallway. We accepted the possibility that we were about to die. We were so frightened, it felt almost peaceful.

We heard the second building collapse — it wasn't that noisy – sort of like waves rushing over rocks at the ocean. It was eerily quiet

for a few moments, then the dust came pouring through the cracks under the front door. After that, in our shock, we felt nothing else could happen, and so returned to the loft. It wasn't until the third building lit up with fire that we realized we must escape. We left everything except the cats and my phone book, and fled.

When did you return?

JH: For the next two weeks we were allowed, sporadically, into the loft to collect things we needed. We had to be accompanied by a policeman or National Guardsman, and were generally allowed 5-10 minutes to gather things up. Once, it took me two hours to find someone to take me in.

On Sept. 26, we were allowed to return home. For a while thereafter, we were in the "Red Zone", fenced in with the site, and had to show identification to bring groceries home. Despite the horror of being there, we experienced great camaraderie. All the neighbors were so happy to see each other again. Once we had returned permanently, I was inexorably drawn to the subject, and began a routine of circling the ruins a couple of times a week, obsessively recording what I could see.

When did you turn your project into a book?

JH: As I drew, snatches of poetry and prose would come to mind. I would take the sketches back to the loft and turn them into watercolors. I sent some to friends and family, just so they would have some idea of what it was like down here.

There are close to 100 pictures in the series, and I chose 65 as the

chronological record. I also preface the record with a few images from the "window a day" paintings made prior to September 11, to give a stronger sense of how irrevocably things changed. I put the pictures into a scrapbook, with some of the poems, and sent copies out at Christmas. This is a personal experience and an historic record. I want to communicate what I saw for this and later generations.

You have chosen verses by some of the world's greatest poets to accompany your work — Wordsworth, Poe, Eliot, Dante, to name a few. How did you choose these works?

JH: Mostly, they were bits I knew. Friends sent some to me when they had seen the pictures. The poems were comforting in that they remind us that this is not a new experience in the world — there is a universality of feeling that has existed through the ages. The words give another perspective with which to deal with the act, the ruins, the loss and the sadness.

How has life in Lower Manhattan changed?

JH: The most obvious change is in the light, the weirdness of the perspectives, the views no one has ever seen. To everyone in and around New York City, the World Trade Center was a powerful reference. For people who live and work here there are moments when we look up, and are reminded, piercingly, what has happened.

* * *

Published in the United States of America
In September 2002 by Gingko Press, Inc.

ISBN 1-58423-116-5 Clothbound Edition
ISBN 1-58423-114-9 Spiralbound Edition

First printing

Gingko Press, Inc.
5768 Paradise Drive, Suite J
Corte Madera, CA 94925
Tel (415) 924-9615 · Fax (415) 924-9608
www.gingkopress.com

© April 2002 by Jean Holabird

Jean Holabird Studio
81 Warren Street, New York, NY 10007
www.birdhollow.com

Library of Congress Control Number:
2002100515

Printed in China

A portion of the proceeds from this work are to be
designated for the Animal Disaster Rescue Fund of the ASPCA

This book is meant to honor
those who perished in, and those
whose lives have been forever
changed as a result of, the attacks
on September 11th

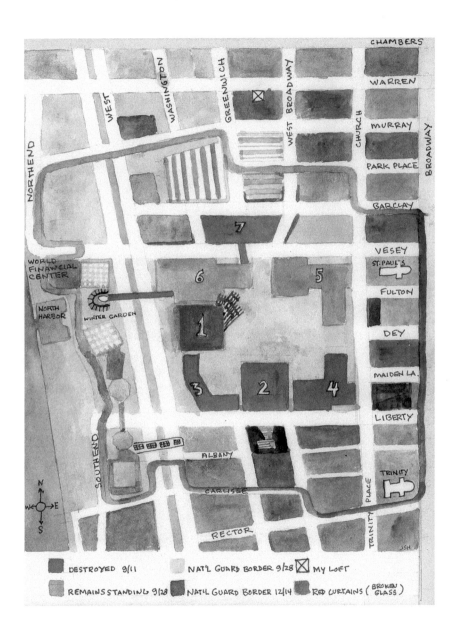

CHAMBERS

WARREN

MURRAY

PARK PLACE

BARCLAY

VESEY

ST. PAUL'S

FULTON

DEY

MAIDEN LA.

LIBERTY

TRINITY

WEST BROADWAY

GREENWICH

WASHINGTON

WEST

NORTH END

CHURCH

BROADWAY

TRINITY PLACE

WORLD FINANCIAL CENTER

NORTH HARBOR

WINTER GARDEN

SOUTH END

ALBANY

CARLISLE

RECTOR

7

6

5

1

3

2

4

N
W — E
S

JSH

DESTROYED 9/11 NAT'L GUARD BORDER 9/28 ⊠ MY LOFT

REMAINS STANDING 9/28 NAT'L GUARD BORDER 12/14 RED CURTAINS (BROKEN GLASS)